How to Get Closer for
PEOPLE PICTURES

Follow these six tips, and they'll all but talk

By Harvey Shaman

Practically all of us in photography make the same basic mistake: we don't get close enough. Yet, tight pictures are the ones that work best.

Have you ever watched others take their pictures? They get their subject all lined up, say, "Hold it," and then start to back away from them. The guy who is making family snapshots is not the only one who is guilty. So are you and I. I have backed into so many obstacles that I have gotten into the habit of looking behind me before I start shooting. The only trouble is, all too many of my pictures prove I should have been going in the other direction.

As a matter of fact, I have a great prescription that I spout loud and long anytime I see someone backing with a camera:

"Get your subject all lined up. Now, find the spot from which you want to make the picture. Stand there, but don't shoot. Instead, locate a spot midway between yourself and move up to that spot. Hold it; don't shoot!!!

"Again find a point midway between where you are now standing and the subject. Move up to that spot. Now shoot. You are finally close enough so you can show what the people look like.

If you really want to make a strong picture, try cutting the distance in half again. Move right in on top of your subject and shoot away."

The basic truth is, most of us are shy. We don't feel comfortable moving right on top of someone. We would rather make "great pictures" from afar. This is the reason manufacturers get rich selling telephoto and long zoom lenses. Photographers feel that such lenses will let them get great close-ups without actually intruding on their subjects.

Unfortunately, long lenses are not cure-alls. More often than not they create as many or more problems than they solve. They are big and generally heavy and awkward to carry around. They require high light levels, even with fast films, because high shutter speeds are needed to counteract camera shake, which is magnified by the number of times the lens' focal length increases over the normal focal length. The rule of thumb is that the shutter speed should match the lens' focal length if you are to be reasonably certain of making a sharp picture while hand-holding the camera; e.g., a minimum of 1/100 sec with a 100-mm lens; 1/250 sec with a 250-mm tele.

If you resort to a tripod, you lose the freedom of movement to find just the right spot to shoot from and the inconspicuousness that prompted you to buy the long lens in the first place. In truth, a long lens is generally a cop-out because you were afraid to actually move in on your subject. All too often, it proves to be an expensive attempt that is seldom used for very long because the end result isn't worth the effort.

So, what *is* the answer? Very simple: You just have to get used to the idea that you are going to have to move in close. If you want to make strong pictures, there is no other solution.

There are, however, working techniques that will help. They will make life easier and will help you overcome those personal and emotional barriers that tend to make us move back into the next county instead of closing in and actually confronting the subjects. A little courage and a few "tricks" will add up to pictures that are a lot more effective. That is what this article is all about. Two professional actors have helped me dramatize my points: Chrissy Penza and Jon Putnam, who are starring in the BRP Theater Projects projection of "The Fantasticks."

New Improved Kodacolor 400

How much better is Kodak's improved ASA 400 color-negative film?
We made comparison pictures, and here's what we found

Old 110 Kodacolor 400
Black-and-white reproduction of 15X Ektacolor 74 RC enlargement shows good sharpness and grain. Now compare this print with similar blowup made from the improved film (r.)

Improved 110 Kodacolor 400
Comparison of original 15X color-print blowups indicates that this one is slightly sharper and has more pleasing grain. It also has slightly more shadow detail, indicating higher film speed.

By Ed Meyers

If you shoot a roll of Kodak Tri-X black-and-white film today and process it just like you did a roll of Kodak Tri-X five, 10, or 20 years ago, the results would be different. Today's Tri-X film is sharper and has finer grain and more effective film speed. The name is the same, but the film is not.

If you compare the prints you get with 110 Kodacolor 400 having a January 1980 or later expiration date, with an earlier version, the results will be different.

According to a Kodak publication, "New technology has led to our ability to improve the grain and sharpness as well as the latent-image-keeping characteristics and underexposure latitude of Kodacolor 400 film. These modifications will be incorporated initially in the 110-size film . . .

It further stated, "We expect these improvements to be incorporated in 135-size film some time in the first quarter of 1979 with 120-size film following shortly thereafter . . ."

The simplest way to find out how the new and old 110 Kodacolor 400 perform is to shoot pictures with both films and compare them.

Using two Pentax 110 SLRs and a set of lenses, comparison pictures were made under several lighting conditions. Some were shot indoors with electronic flash, and others outdoors with and without flash. The pictures reproduced here were made on a cold, snowy winter afternoon without flash. Both were shot with the same 50-mm f/2.8 lens switched from one Pentax to the other. I didn't know the f-stop or shutter speed—only the cameras knew what

combination they had selected.

Both rolls of Kodacolor 400 were sent to Kodak in prepaid mailers for processing and printing. About a week later, the processed negatives and 3½x5-in. prints arrived. We placed them side by side to compare the results. All had good color and seemed to be sharp. Sure, there were slight differences between "new" and "old" pairs. But that could have been caused by the negatives having been printed by a different machine. It was apparent, however, that in scenes where there was lots of snow, darker tones had more detail with the newer Kodacolor. The new film has slightly more sensitivity. Snow often fools light meters into believing there's more light reflected back from subjects than there really is, resulting in underexposure /continued on page 174

Tip 1: Cut off all excess—close in

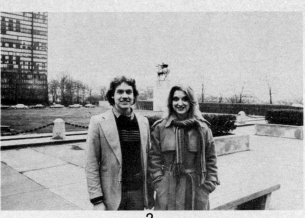

2

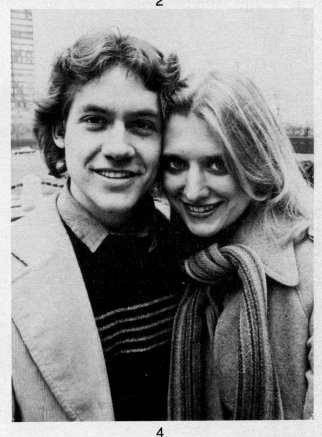

1

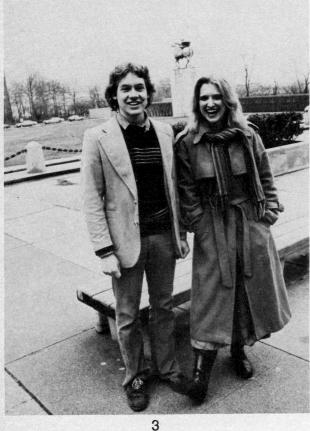

3

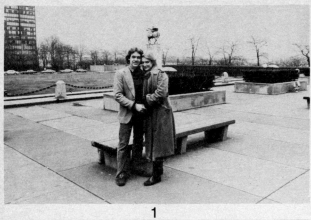

4

Most snapshots are made distantly. We plant out companions in front of some landmark so we will have a record of having been there; a remembrance, too, for the years ahead, **1**. Yet the essentials of the photograph, the subjects, occupy only a tiny fraction of the total picture area. Perhaps the statue in the background is one reason for having made the picture, but I doubt that the building on the left or the man walking out the other side are of any interest. What has happened is that we are afraid we will miss something. And, in reality, that is exactly what has happened. We have missed our subjects entirely by making them so small and insignificant that few details are really distinguishable.

By cutting the distance in half, **2**, we have reached the position where we should have been in the first place. Study the picture carefully. There are still things we can do to improve it. We don't need the building on the side. As a matter of fact, we don't need any of the emptiness of the sides. Most important, our subjects are pictured only half the size they could have been.

The solution is to turn the camera vertically instead of holding it horizontally, **3**. By tipping the camera slightly downward we can get in their feet and still have the statue in the background, as well as enough open space around our models to establish the location.

If we really want a strong image, the thing to do is to foresake the statue, and keep moving in until Chrissy and Jon completely fill the viewfinder, **4**.

Tip 2: Mate frame to shape of subject

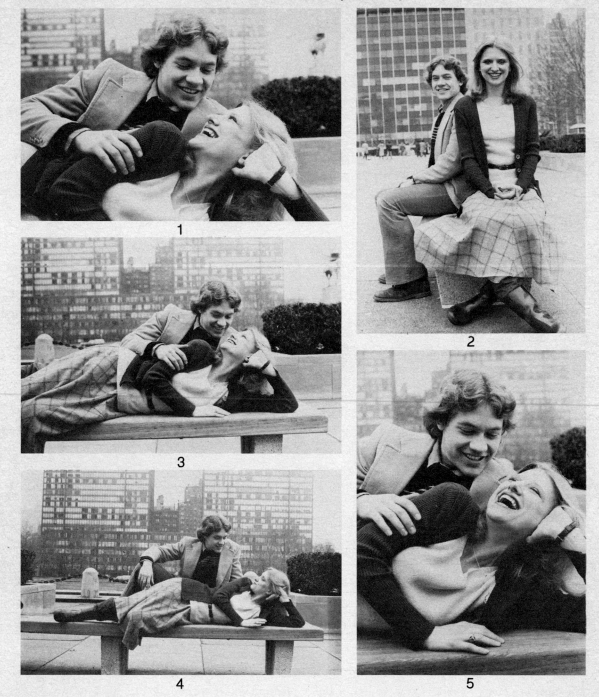

Because of the design of the 35-mm camera, the normal manner of holding it results in a picture with a horizontal format, regardless of whether or not the subject lends itself to a horizontal rectangle. The solution is to learn to turn the camera to fit the subject. Remember, the photographer is responsible for everything that ap-

pears in the final picture, not just the image of the central subject. Look carefully at all areas of the view in your camera's finder. If the subject is basically horizontal, then hold the camera level, 1.

However, if the dominant lines are up and down, the way to make a larger image and not waste space is to ro-

tate the camera 90 degrees and make a vertical picture, 2. One of the big dangers is to arbitrarily decide to make a picture of a particular format, even if the subject does not lend itself to that. As a result, part of it is often cut off while unimportant areas such as the empty ground in the front are included.

There is nothing wrong,

however, with cutting off part of the subject if it is unimportant or fails to add to the picture, 3. Surplus merely detracts.

Sometimes a composition or subject will work either vertically, 4, or horizontally, 5. The main factor is to be aware of what is happening and how the subject actually looks in the viewfinder.

Tip 3: Less is more

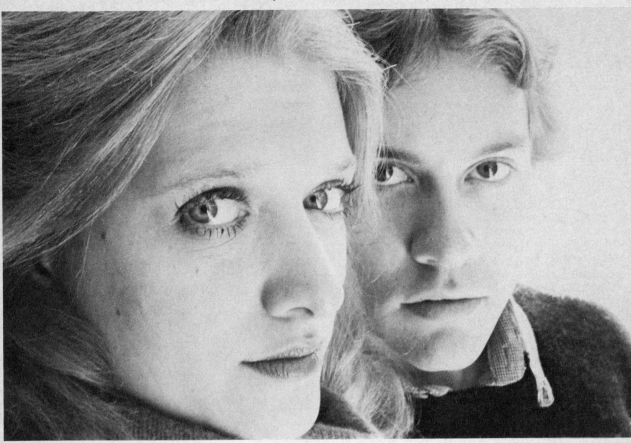

1

We tend to be reluctant to crop into people. It's almost as if we were afraid of hurting them. But we are not capturing their souls or their bodies, and our cameras are not evil eyes. We are merely recording an image, and nowhere does it say that we have to show the whole thing. Quite often an image of just a section of a subject can reveal as much as or more than showing the entirety. In a close-up, we can show our subject in detail.

Make it a practice to stop and ask yourself what is the essence you are trying to capture. Soon this will be second nature to you, and find yourself working as fast as ever.

Don't hesitate to come in very close, to crop out all that is superfluous **1**, or even reach in for just a detail **2**. One danger of getting too close is the possibility of distorting the image. Because

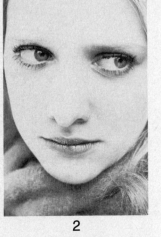

2

you are so close, the part of the subject closest to the camera can look proportionally too large compared to the rest. The solution here is to select a much longer than normal focal-length lens, such as the 135-mm telephoto in this shot **3**. Or, judiciously, select a camera angle so that all parts of the subject are the same distance away.

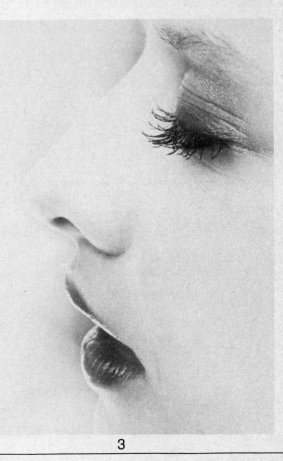

3

Tip 4: Don't disturb—shoot candidly

The desire to make candid photographs of people is dearly beloved by all manufacturers of telephoto and longer zoom lenses. Photographers figure that if they just have a long lens they would be able to get those great natural candids of people without actually having to intrude on them. It is true. It can be and often is done that way but, for the most part, good candids are the result of moving right in on top of people and not by backing off into infinity and popping away with a telephoto or long zoom lens.

How, then, do you do it without disturbing people, and stopping them from whatever they are doing, 1?

There are several procedures to make such shooting easier.

The first step is to be completely familiar with your equipment. Nothing is more obvious than a photographer who walks up to a subject and begins fumbling around, taking light readings, focusing, and making camera settings.

Whatever has to be done to the camera to take pictures must be done before you actually become involved with your subject, not afterwards.

Next, be completely relaxed and natural in your approach to your subjects. In some situations they may be so engrossed in their own activity that they are unaware of you, and consequently you can practically put your camera into their faces. This is true, however, only if you are so familiar with

your equipment and so relaxed and natural about what you are doing that you don't call attention to yourself.

In another type of situation, the subjects may well be aware that you are photographing them, but are more interested or concerned with what they are doing than with you, 2. In such a case, it is possible to move in close without disturbing what is going on. Again, the key is equipment and technique familiarity. You must be so sure of yourself that you don't intrude.

The final situation is the one where the subjects are very much aware that you are there. They may very well not want their picture taken, yet they are doing something which is very interesting. How do you cope with that?

One procedure is to pretend to take pictures of something else. The technique depends on the way you use your eyes. You never look directly at your subject. You gaze through or beyond them as if you were taking a picture of something or someone beyond.

I have actually pointed a camera at persons from a very close distance while they were looking almost directly at me. However, the camera would not be completely in front of my face, and I would pretend to look into the distance. Their reaction is almost always one of puzzlement. They think at first that I am looking at them. Then they seem to realize that I am completely unaware of them and that I

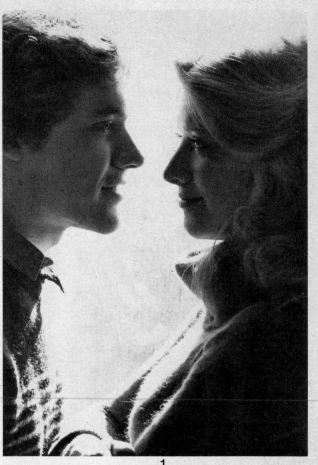

1

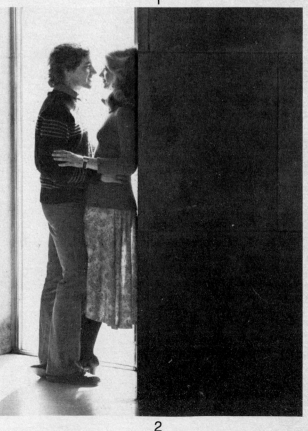

2

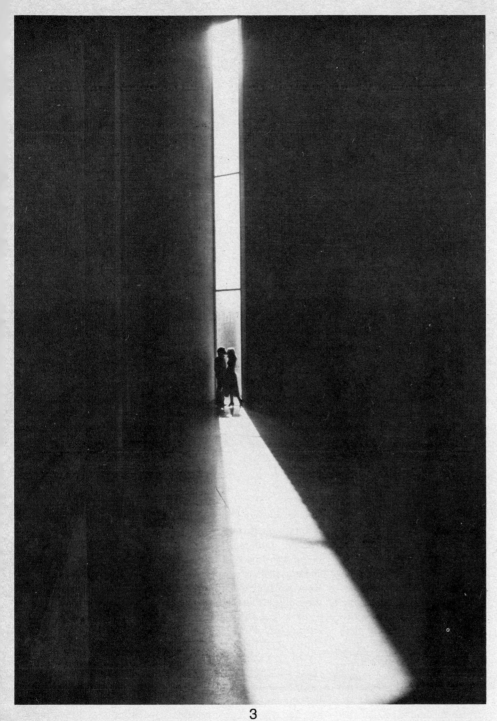

3

am watching something else. They turn around to see what it might be. They are puzzled and not quite sure, and may repeat this action several times.

Then one of two things happens. They either turn their back to me, or they figure I don't see them and continue with what they were doing. The only time

this ploy ever failed was in a French farmers' market. I pointed my camera at an old peasant woman with a basket full of eggs for sale. She rushed toward me and took a swipe at my camera. I beat a hasty retreat.

Another technique is to preset everything. Guess the distance or focus on something at approximately the

same distance as your target. Preset the exposure, using the fastest shutter speed possible. Then mentally pre-frame your subjects so when you actually point the camera at them you will know exactly what will be in the picture and where to place it. You should be facing in a different direction, but close enough to see them out of

the corner of your eye.

When your subjects realize that you have no interest in them, and go on doing the thing that interested you in the first place, you are ready to shoot. Bring your camera up to your eye, swing around toward them, frame the image as you had previsualized, freeze momentarily, and squeeze off the exposure. As soon as the shutter is released, drop the camera back down. With practice, the whole exercise takes no more than a second.

More often than not, the subjects don't realize you have made a picture, simply because few people know it can be made that quickly. They are almost always used to the standard jockeying around that accompanies the taking of even the simplest snapshot.

Of course, you can always shoot candids of people from a distance, **3.** Sometimes it even works well. You can be quite certain they will never be aware that you are there.

In contrast, at very close quarters, there is almost no way that you are going to shoot a picture without your subjects becoming aware of what you are doing. The only answer is to make the picture as unobtrusively as possible, using the techniques described above. Preset the camera and when they realize what you have done and stop what they are doing, it is already too late. You have the picture, and that is the name of the game. However, be ready to run, just in case.

Tip 5: Go formal

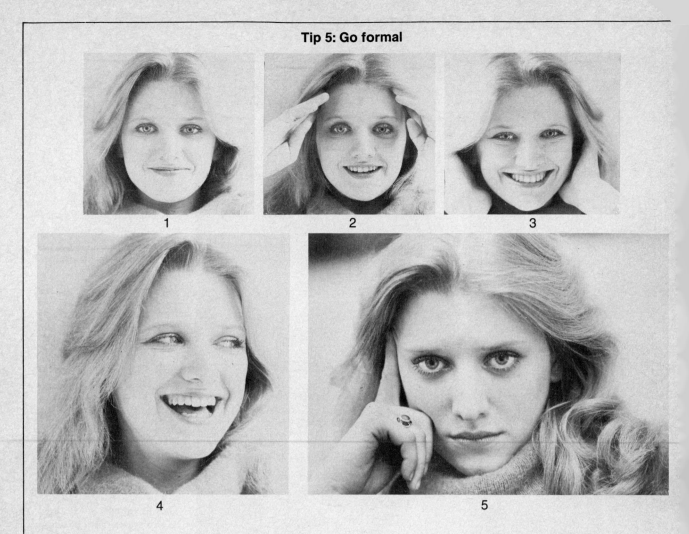

1 2 3

4 5

One excellent way to get tight close-ups is to completely control your approach. Work in exactly the same way as the professional portrait photographer. Select an appropriate background. Seat the subject in front of it. Arrange the lights and put the camera on a tripod. As you can make all possible preparations, technical quality should be superb. Only after the setting up has been completed do you worry about taking pictures.

You make the picture, actually manipulating your subject, by getting them to relax in front of the camera so that you capture a true image of them rather than just a likeness. The difference is distinctive.

A likeness will emphasize a person's good points and play down the bad ones. A third person who looks at such a picture, if it's well done, will say, "It looks just like you." This is the type of portrait most formal portrait studios produce. The pictures look just like the subjects, and generally flatter them, making them look a little better than they do in real life.

A true image of a person is something different. It captures some aspect of the subject's features or personality that, when the picture is viewed by others, will evoke the reaction: "That's Chrissy, alright, that's the way she really is." The picture may not be flattering. It may not play down shortcomings, but the viewer's reaction will be that the picture is real.

To make such a picture, it is wise to avoid the use of dramatic or formal lighting. The soft light coming from a large window or the open shade outdoors works well. Because such photographs generally are made up close, a simple background is called for. The real key is that everything is locked down so you can concentrate on the subject. The camera is on a tripod, the lighting and background are set, and a long cable release is attached to the camera so you can move away from it if you choose.

There are two approaches. One is to talk to your subject, and have him talk back to you so that you can capture the animation, vitality and gestures that are characteristic of that person, **1** through **4**.

The other is to keep quiet.

You don't talk to the subject. Instead, you have him or her look directly into the camera lens and then you wait. Any expression will gradually fade, and finally his face will acquire a completely neutral look, for no one can hold an expression for more than a few seconds without it becoming strained and unnatural. The result, **5**, will be completely neutral. You will get the feeling when looking at the picture that you are peering into the person and that he has laid himself open to you so you can see his real self.

This is the same sort of look we see in portraits made during the early days of photography and in paintings where the subject had to sit perfectly still for a long period in order for an image to be recorded.

Tip 6: Open up space

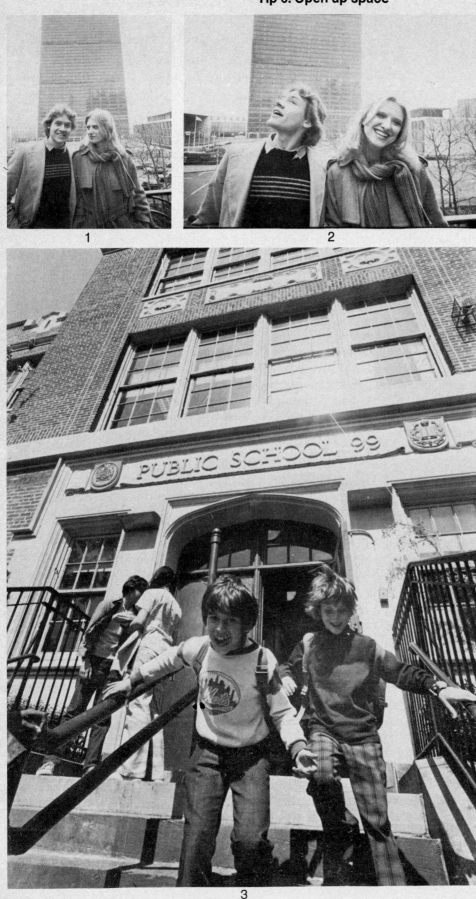

1

2

3

On occasion, you close in on your subjects to make them dominant, but also want to include the broad sweep of location. Your problem is angle of view. With the normal lens—the 50-mm one in the case of 35-mm photography—you cut out most surroundings as you move in. To counteract this, try a 35-mm or even shorter wide-angle lens. It can include the setting at sides, top, bottom.

One danger of the wide-angle lens is that it will often introduce distortion. For example, it is apt to elongate circular objects at the sides and corners—so try to center them.

Perhaps an even more pronounced form of wide-angle distortion is convergence—actually perspective—caused by tilting the camera. By carefully centering Chrissy and Jon in the lower third of the format, **1**, I was able to get them with the United Nations tower in the background. However, because of the tipping, the lower part of their bodies were closer to the camera, and consequently are slightly out of proportion. This is not excessive here.

Still, such distortion can be avoided altogether: this shot, **2**, was made with a 20-mm lens, but with the camera scrupulously kept level. The wide-angle lens gives you the feeling of being close to the couple, yet you are aware of the buildings in the background.

It is intimacy that makes the wide-angle such a powerful people lens; witness my final example, **3**, of my son and his friend rushing out of school. The lens gives them prominence but still includes their environment. Shot from a distance with a telephoto, the picture wouldn't have been anywhere near as effective. As I said before, tell it up close. ●

New Photo Products for 1979

A report from the Chicago PMA Show

By Arthur Goldsmith

Chicago—This year's 55th Photo Marketing Association convention and trade show, held during winter's last blitz in the Windy City near the end of March, was from the product standpoint largely a replay of *photokina* '78, plus items first shown at pre-PMA press conferences and already reported to POP PHOTO readers. Not that there wasn't an abundance of new items, including lenses, electronic flash, darkroom equipment, accessories, and sundries. There was, and we've wrapped it all up for you on the following pages with an update of prices and availability of products first shown at *photokina*.

Thirty-five millimeters straddled the gamut from gold-plated Luxus Leicas commemorating the 100th anniversary of inventor Oskar Barnack to a mostly plastic SLR with pop-up flash and noninterchangeable lens from Hanimex that will probably sell for not much more than $100. However, the heavy emphasis this year definitely was plastic, not precious metals. As it all comes together, the '79 PMA Show assumes importance as the launching pad for a new breed of relatively inexpensive automatic cameras.

They are harbingers of a massive marketing effort designed to maintain and expand the booming sales of 35-mm SLRs which last year topped two million. Automated production techniques, simplified design, and a greater use of plastic in camera body and lens mounts have been combined to hammer down the selling price, if not suggested retail tab, to well below $300 in some cases. They are designed for economy and simplicity as "entry-level" cameras for 110 or instant photography snapshooters moving up to their first purchase of a 35-mm SLR.

What many of these new cameras such as the Canon AV-1, Nikon EM, Olympus OM-10, the Hanimex Reflex Flash 35, and a rumored (but not shown) Fujica low-cost SLR have in common is compactness, light weight, full exposure automation, and no shutter-speed dial. (An integrated electronic-flash unit and auto-winder also are available for the first three.) They are going to be promoted by the most lavish (and expensive) television campaign, estimated at $70 million or more, the photographic industry has ever launched in an all-out campaign to broaden the SLR market. (You probably will have seen some of the new commercials by the time this issue reaches you.) What will happen is anybody's guess. It could result in speeding up the expansion of those people who become seriously involved with photography, or it could mean a disastrous price war that ultimately benefits nobody, including the consumer.

Meanwhile, compact 35-mm cameras with pop-up flash, and in some cases automatic focusing, will become widely available in various models. The unusually designed, ultracompact "clamshell" 35-mm rangefinder XA-1 from Olympus is being offered for an attractive price, and Pentax is going all out to promote its unique Auto 110 SLR system. In 1979, folks interested in getting into photography won't lack for options when it comes to that first camera. ●